David Sanders Howell

For the grandchildren: Crister, Madeline and Makenzie

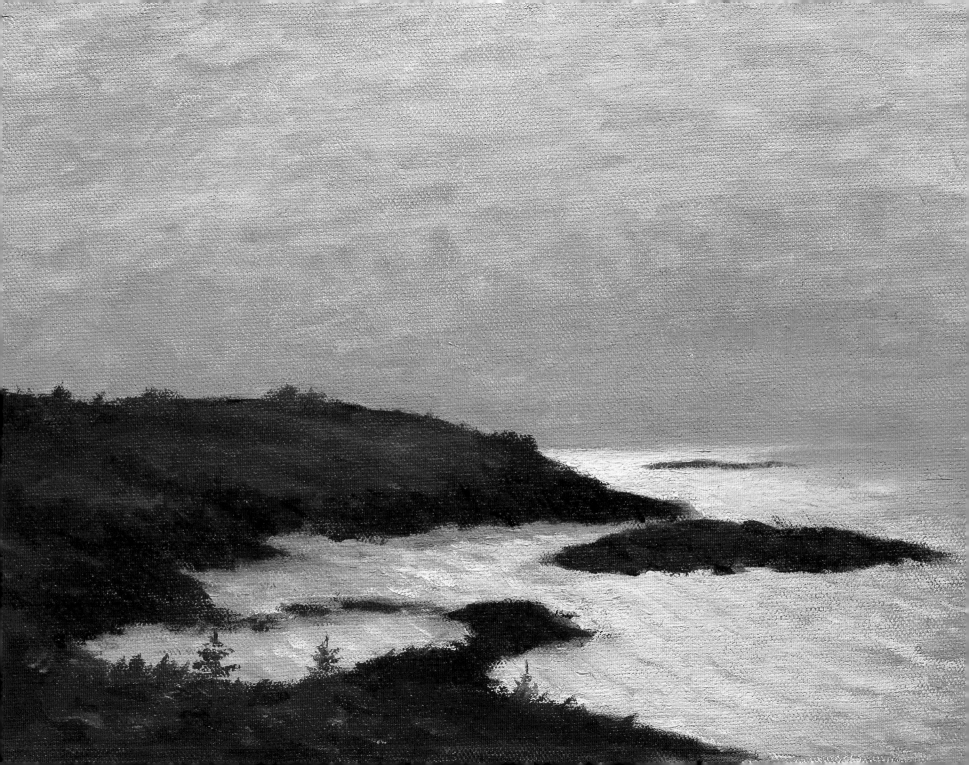

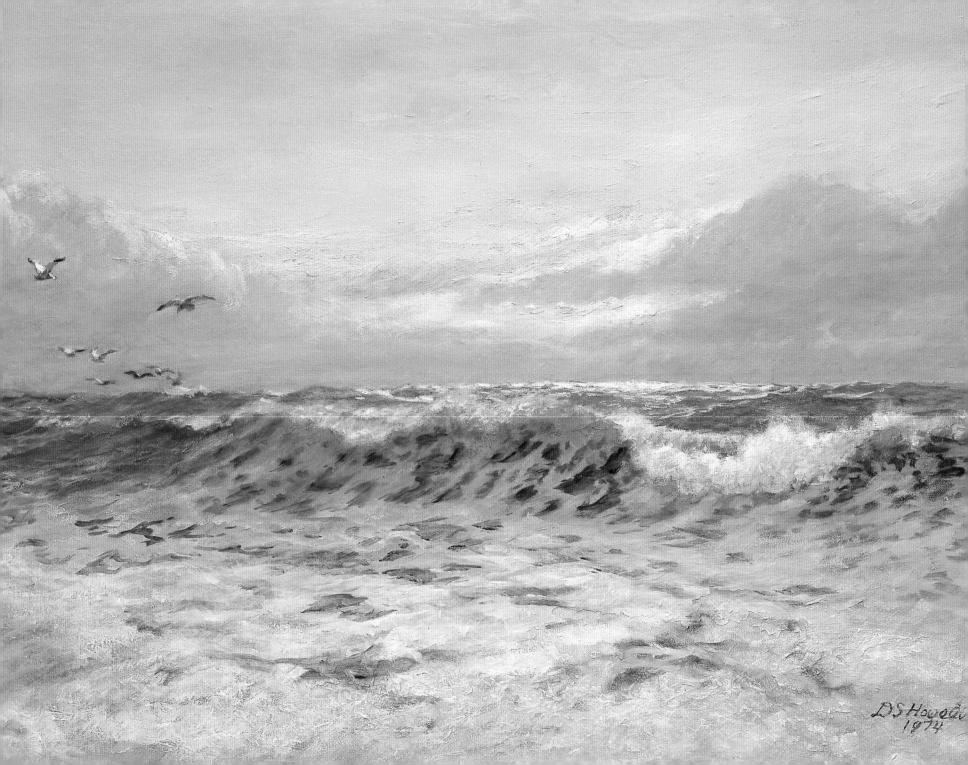

by David Sanders Howell

seascapes

Published by David Sanders Howell and Margaret Blue Howell *Coral Gables, Florida*

First published in the United States of America in 2004 by
David Sanders Howell & Margaret Blue Howell
1236 Milan Avenue
Coral Gables, FL 33134

Design by Suissa Design, Hollywood, Florida
Photography: Tim McAfee Photography, Inc., Miami
Printed and bound in China
Library of Congress Catalog Card Number: 2003093980
ISBN: 1-886438-02-1

Distributed by
Grassfield Press, Inc.
P.O. Box 398825
Miami Beach, FL 33239-8825
tel 305-538-1033 *fax* 305-538-1096
books@grassfieldpress.com

Cover: Bright Moonlight in Gulfstream, 1974, *Oil on canvas, 18 x 24 in.*
Page 1: Isle of Shoals, 1997, *Oil on canvas, 11 x 14 in., (New Hampshire)*
Page 2: Early Morning on an Outer Reef, 1971, *Oil on canvas, 24 x 36 in.,*
 (Hopetown, Bahama Islands)

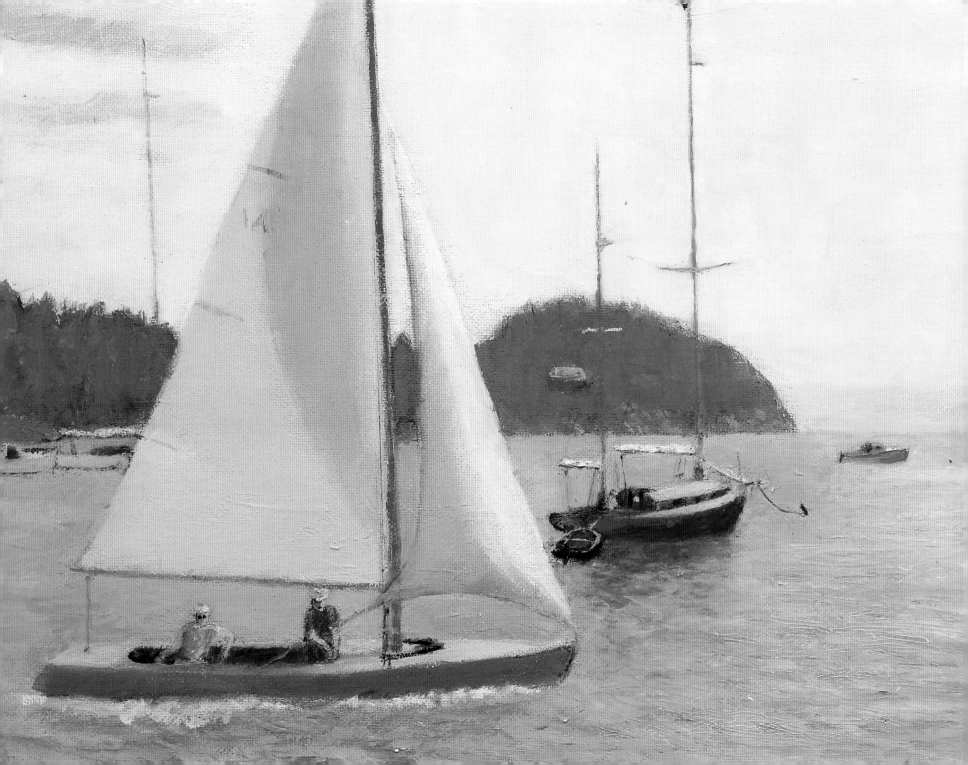

6

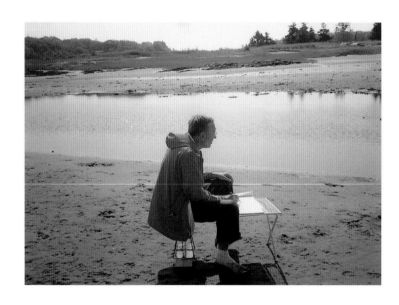

Author sketching on tidal flat near Edwin Gamble's studio, Georgetown Island, Maine.
(photo credit: Edwin Gamble)

I am not a fan of cold weather. My childhood preference in the northern climate of Montclair, New Jersey, was to spend the winter months inside reading cowboy stories and sea adventures. I was born there October 4, 1923. Although I was an only child, my cousins, Sid and Mary Johnson and Chuck and Sally Sanders, were surrogate siblings. From ages three to thirty-three, I spent happy vacations in Boothbay Harbor, Maine. Our house was built on a cliff overlooking a bay leading out to the sea. Memorable drives were taken on rustic roads to Pemaquid and Ocean Points, Newagen and Hendriks Head where I remember a lighthouse once stood.

My father worked in sales for Bradstreet Co., a credit firm located in New York City. When he took me to his workplace, we rode the train from Montclair to Hoboken, New Jersey, and a ferry across the Hudson River to Manhattan. In those days, the river was alive with ships and tugboats. My father brought me posters and photographs of locomotives and ships from his corporate clients. He retired when Bradstreet merged with Dun. At age eleven, I visited the Montclair Art Museum and for the first time was emotionally stirred by a painting, Frederick Judd Waugh's "The Green Wave."

Around age twelve, I spent the summer taking watercolor classes at the Anson Cross Art School in Boothbay. In the fall, my parents moved to Tryon, North Carolina. I enrolled in the Asheville School For Boys, a well-known preparatory school nearby. During my four years there, I was introduced to oil painting by Mrs. Wilbur Peck and

also studied with artist-in-residence Emil Holzauer, an illustrator and painter. This introduction led to my life-long enchantment with the oil medium. I studied with Mr. Holzauer for two summers on Monhegan Island, Maine, as well.

My mother arranged a visit to my idol Frederick Waugh in Provincetown, Massachusetts. His studio was a large room with a fireplace, high ceilings, a skylight, and a huge partially finished canvas on his easel. Mr. Waugh was in ill health, but his wife kindly led us to the bedroom where we had a brief interview with him. I was brazen enough to show him one of my small paintings. He was gracious and gave a short critique.

As a pre-med student at the University of North Carolina, Chapel Hill, from 1942 to 1943, I minored in art history. I completed my pre-med studies at Bowdoin College, Brunswick, Maine, and began Harvard Medical School in 1944. Following my first year of internship in 1948, Margaret Blue and I were married at the Coral Gables Congregational Church. After many years of postgraduate training, I joined the faculty of the University of Miami School of Medicine and began my academic career. There was very little time for painting from 1944 to 1970. My wife and I chartered a thirty-five foot sloop several summers with our friend, Wells Coggeshall. We sailed south from Cape Cod to Milford, Connecticut and north as far as Campobello Island, Canada, with stops along the way. Fishing was never a special interest, instead, I preferred observing the ocean in its various moods.

In Miami, I crewed for years on the Kiaora, a sloop owned by the late Dr. Franz Stewart Sr. Subsequently, Margaret and I owned an Irwin 30 cutter, the Horizon, with Bob and Sue Gardner. Both sailboats were docked at the historic Biscayne Bay Yacht Club, an easy access to the spacious bay and the Florida Keys. Unfortunately during Hurricane Andrew in 1992 our boat became the Lost Horizon.

In the early 1960's, I received a two-year research fellowship to the Nobel Institute in Stockholm, Sweden. Margaret and the children, ages nine, five, and one, had to leave the subtropics of Miami and quickly adapt to the Scandinavian winter. We lived on the island of Lidingo in an archipelago bordering the Baltic Sea. Multiple voyages across those waters and the North Sea ensued. By the 1970's, I had established an international reputation in the field of arthritis and mineralization of cartilage. The academic invitations to lecture in America and distant lands, led to further opportunities in art.

I especially enjoyed taking courses at Mounts Bay Art Center in Cornwall, England. These training periods in 1978 and 1980 included presentations on marine art painting. Each day was spent site painting at landmarks in the Penzance area supervised by artists Bernard and Audrey Evans. Once, I joined them for painting instruction on Ischia, a volcanic island west of Naples, Italy. Back in Miami, I enrolled in a class at the Metropolitan Art Center, then located near the old ballroom of the Biltmore Hotel in Coral Gables, Florida.

Soon thereafter, I received painting lessons from Marlene and Harold Putnam at their art studio in Rockport, Massachusetts, and attended lectures by artists at the adjacent Northshore Art Center. We painted on the rocky shore between Rockport and Gloucester where we studied the anatomy of waves and ways to capture them in paint.

In the early 1980's, I became a juried professional member of the International Society of Marine Painters. The notice taken of my artwork by the University of Miami Marine Science Dean F.G. Walton Smith, and his wife Mae also was encouraging. Walton, who had written authoritatively on the physical aspects of ocean waves, invited me to present an exhibition of twenty-five paintings at the annual meeting of the International Oceanographic Foundation. The Dean purchased one of my surf paintings for his office. I had two shows at the University of Miami Medical Library, each of which included forty-five paintings. One of the pictures still hangs in the office of Henry L. Lemkau, Jr., Director and Chairman, Louis Calder Memorial Library.

This book is a selection of seascapes created over a lifetime. When I am asked what other subjects I enjoy painting besides the ocean, my reply is that I never have tired of addressing the majestic sea.

David Sanders Howell

A TRESTLE SOUTH OF TRYON, N.C., 1940 | *Pencil on paper* | *12 x 17 in.* | *(Drawing made while at Asheville School)*

ACKNOWLEDGEMENTS

Those of you who know Margaret, will be aware of her devoted, capable presence in this book. Others I wish to recognize are photographer, Tim McAfee; James Clearwater of Grassfield Press and his wife Bonnie; Joel Suissa of Suissa Design; Joseph DiNatale; and Geneva Jackson.

Encouragement in art, in various ways through the years, came from Holly and Margaret Smith; Edwin Gamble; Rudolf and Katarina Lemperg; Helen Schaffer; Patty and Bob McNaughton; Caroline Hunter; Kenneth Kniskern; Alice Jean Larkin; Sue Spear; our children Linda Lee, David Jr., and Walter Howell; and especially Alice Brock, who kept pushing me to paint.

David Sanders Howell

12

plates

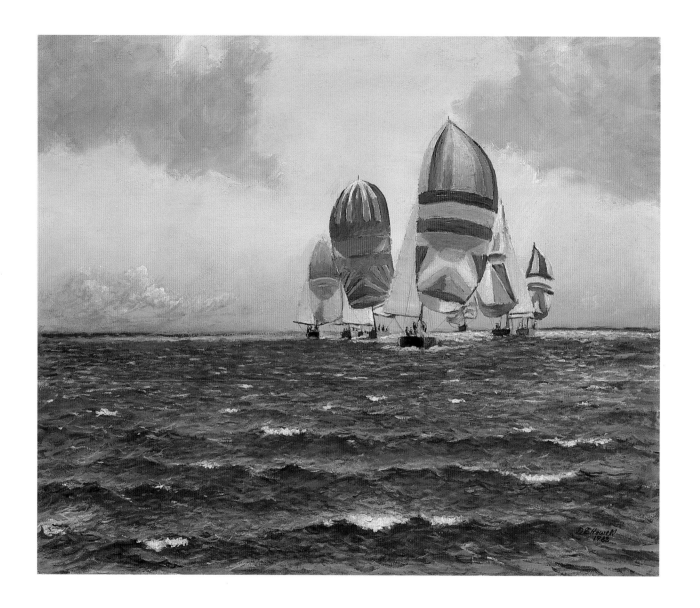

WINTER WINDS, 1988 | *Oil on canvas* | *20 x 24 in.*

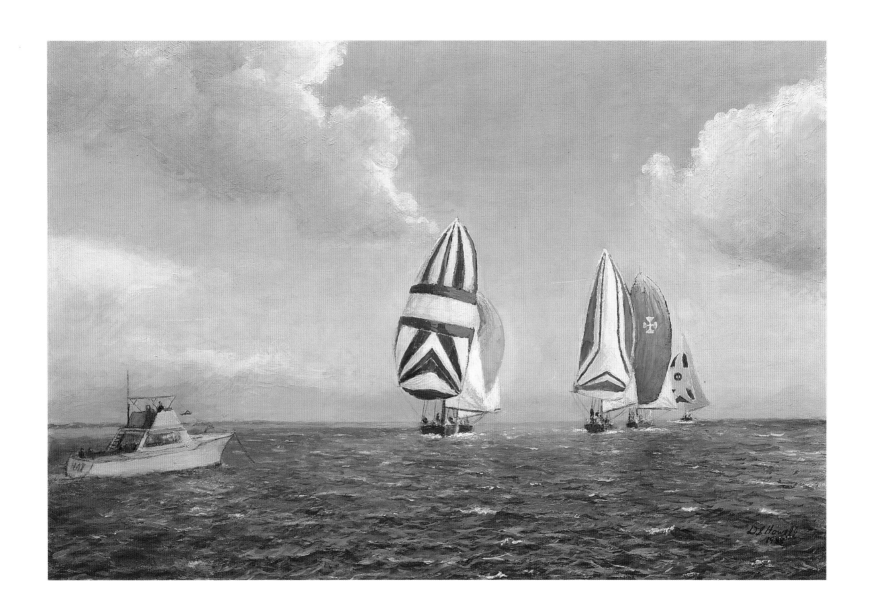

A Close Finish, 1988 | *Oil on canvas* | *20 x 30 in.*

BEFORE THE RACE, 1997 | *Oil on canvas* | *12 x 16 in.*

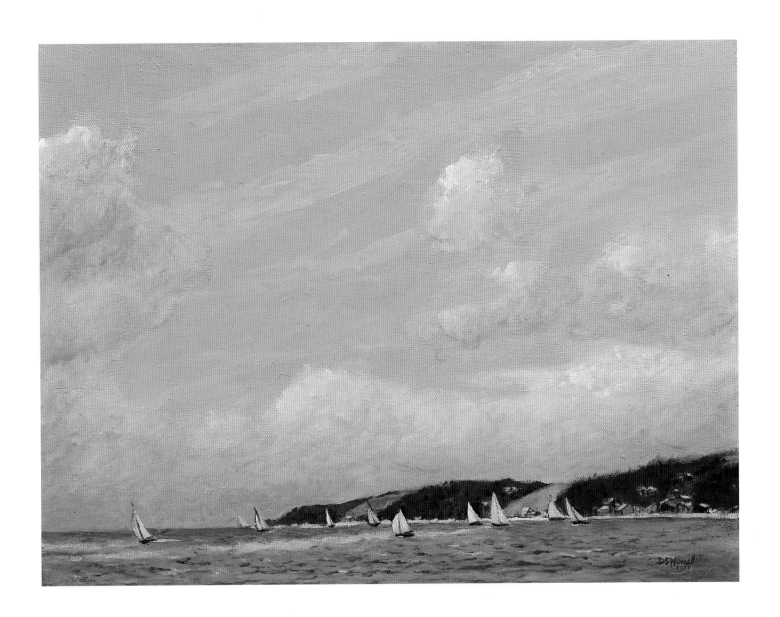

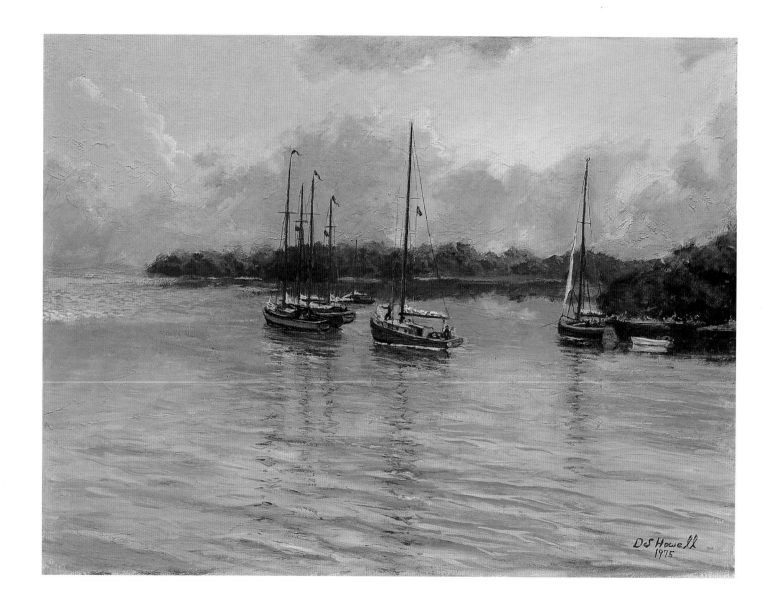

SUNRISE AT SANDS KEY, 1975 | *Oil on canvas* | *18 x 24 in.*

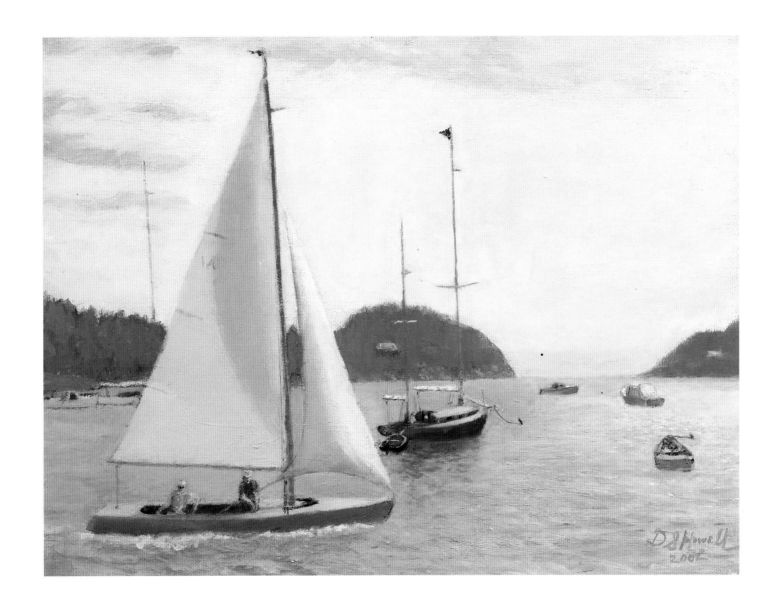

SHEEPSCOT BAY NEAR FIVE ISLANDS, 2002 | *Oil on canvas* | *12 x 16 in.* | *(Maine)*

SUNSET OFF KEY LARGO, 1979 | *Oil on canvas* | *24 x 36 in.*

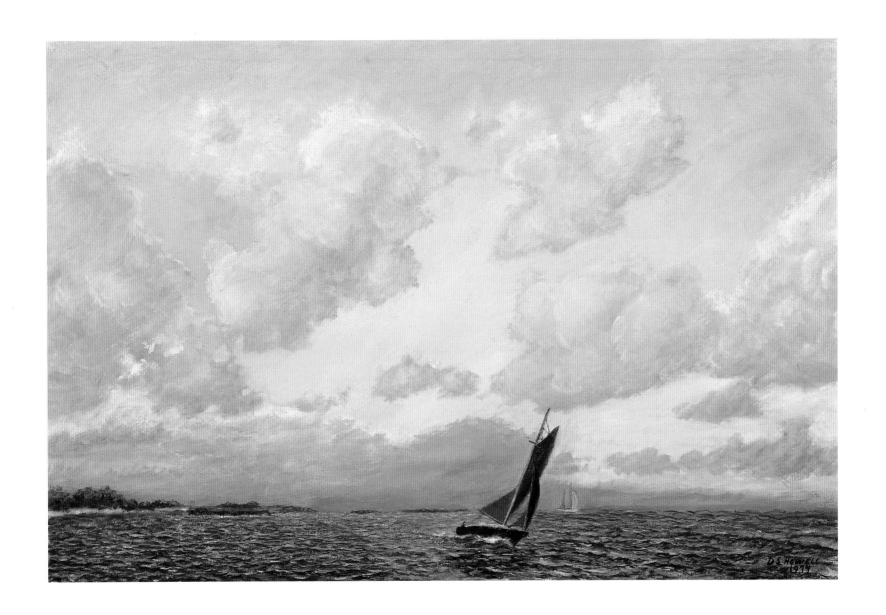

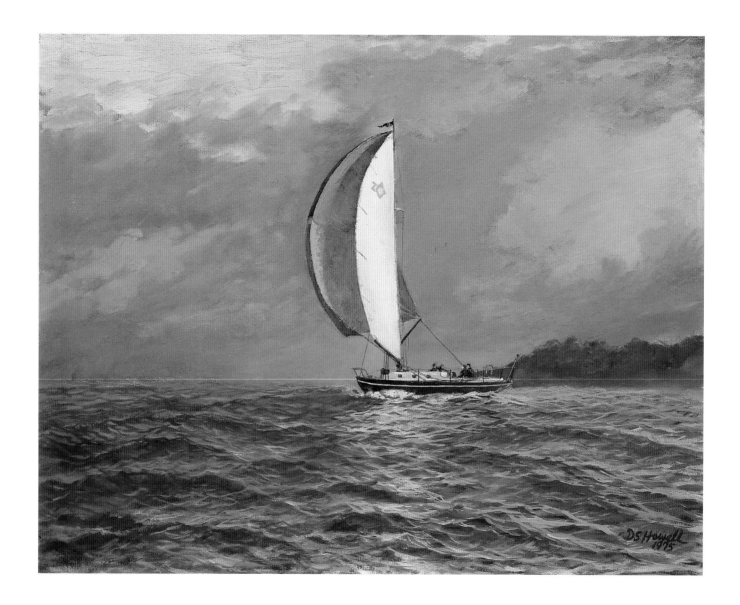

34 Foot Sloop, Kiaora, 1975 | *Oil on canvas* | *22 x 28 in.*

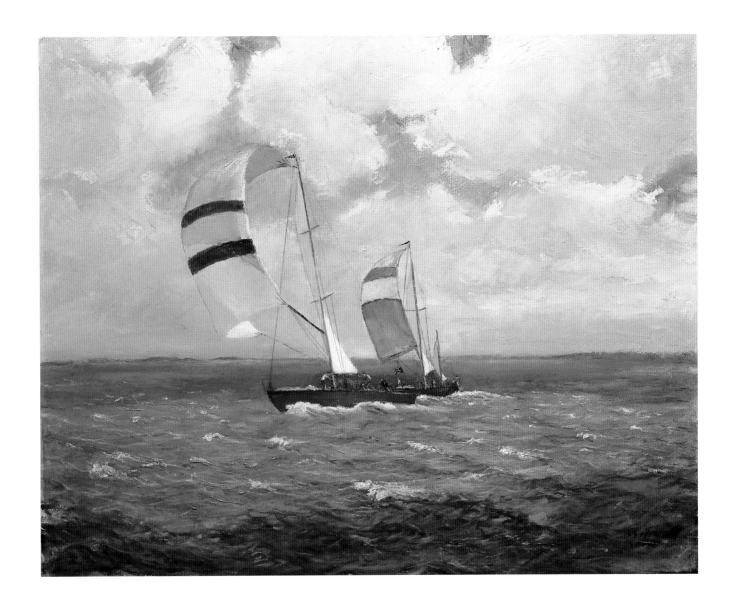

RACING PAIR BEFORE A SOUTHWEST WIND | *Oil on canvas* | *22 x 28 in.*

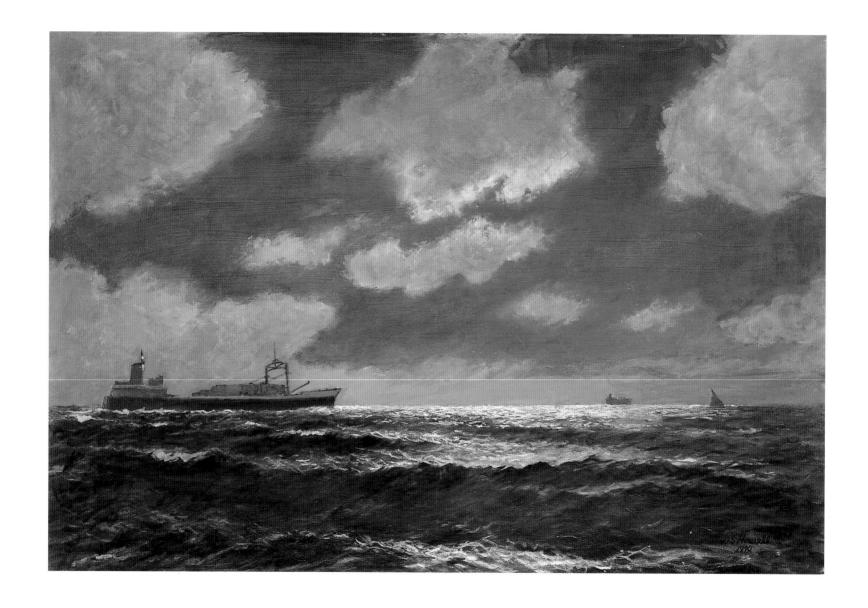

FREIGHTERS MOVING SOUTH ALONG WEST SIDE OF GULFSTREAM, 1990 | *Oil on canvas* | *24 x 36 in.*

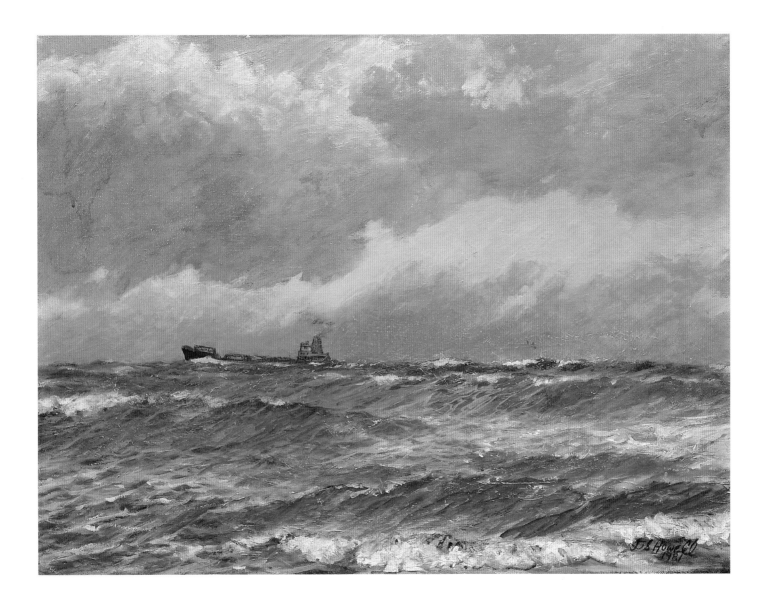

COASTAL FREIGHTER IN GULFSTREAM, 1981 | *Oil on canvas* | *18 x 24 in.*

26 Morning Storm Cloud, 1960 | *Oil on canvas* | *24 x 36 in.*

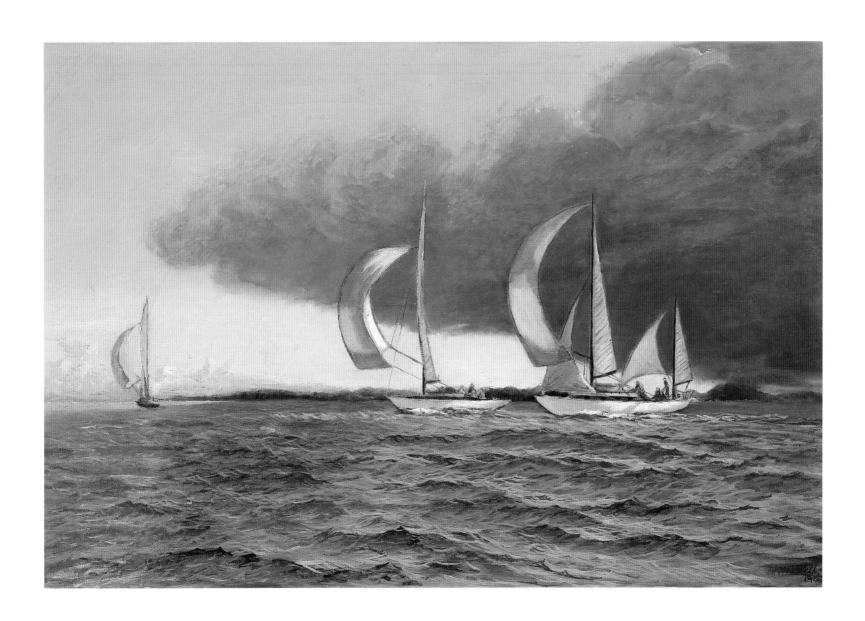

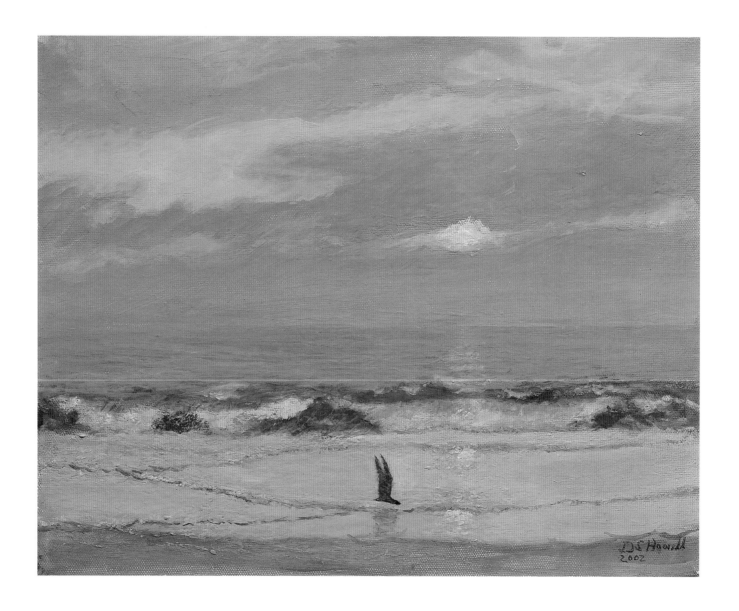

BEACH SCENE, 2003 | *Oil on canvas* | *11 x 14 in.* | *(Ogunquit, Maine)*

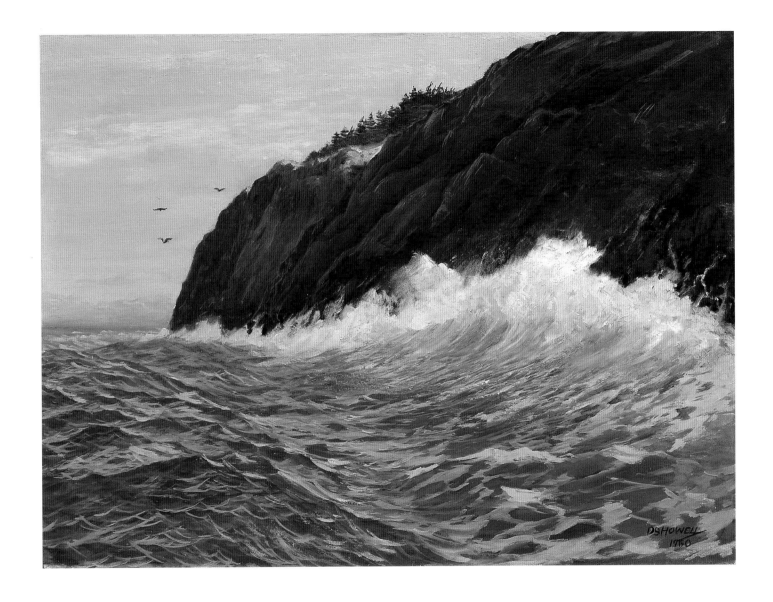

EAST SIDE OF MONHEGAN ISLAND, 1960 | *Oil on canvas* | *22 x 30 in.* | *(Maine)*

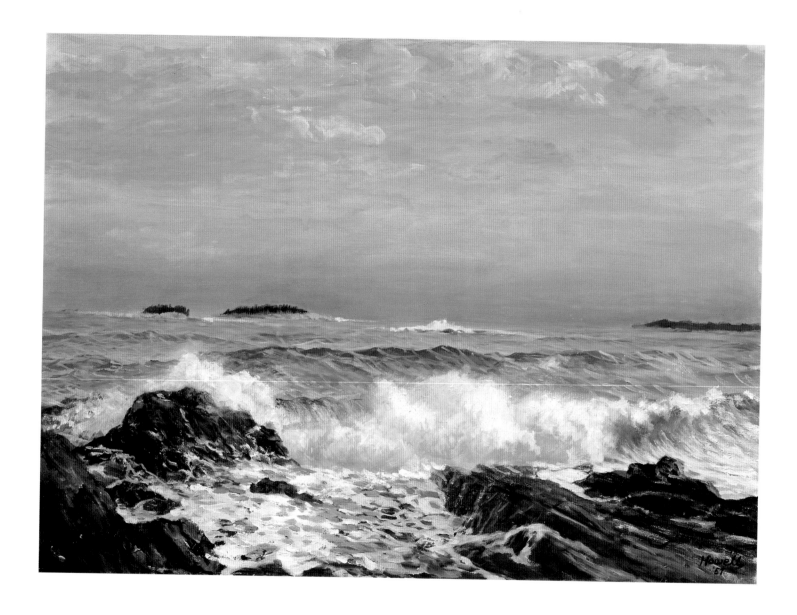

OCEAN POINT, 1957 | *Oil on canvas* | *26 x 36 in.* | *(near Boothbay Harbor, Maine)*

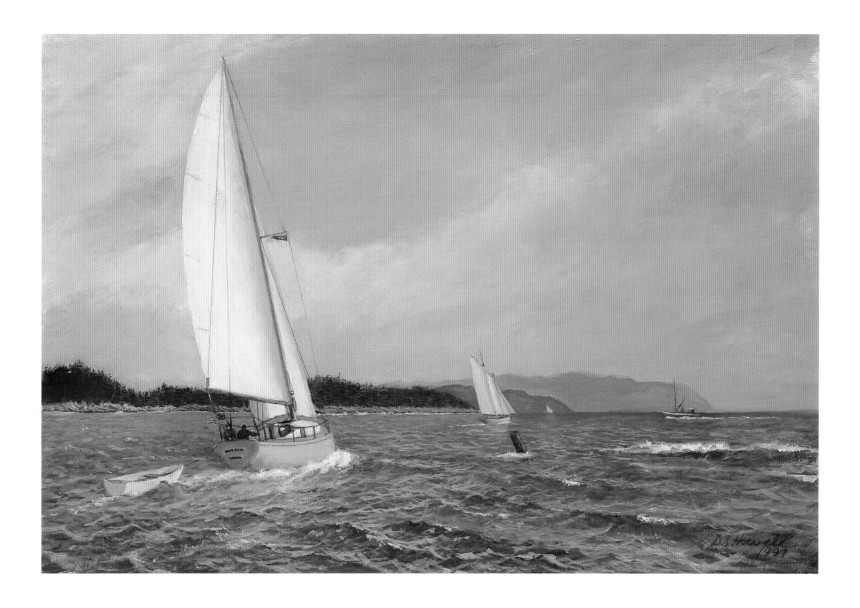

SAILING SCENE SOUTH OF BLUE HILL, 1994 | *Oil on canvas* | *24 x 36 in.* | *(Mount Desert seen in the distance)*

PRIDE OF BALTIMORE, 1983 | *Oil on canvas* | *23 x 36 in.* | *(Lost at sea in a squall north of Puerto Rico in 1976)*

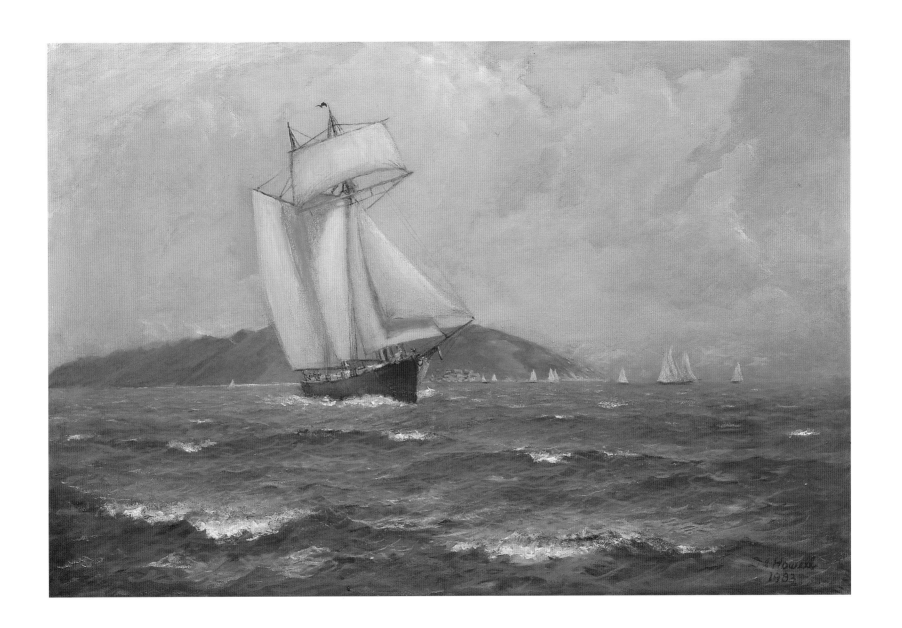

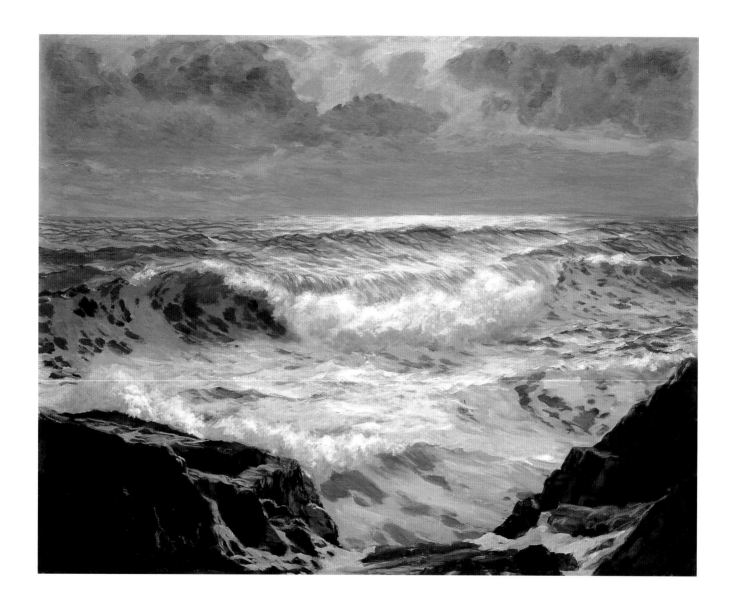

LA JOLLA SURF, 1949 | *Oil on canvas* | *24 x 36 in.*

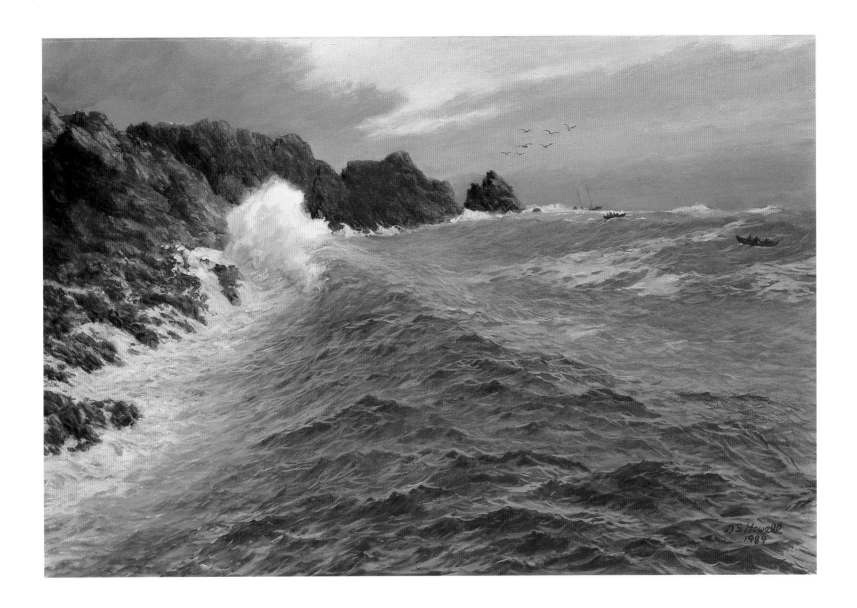

SUNSET NEAR MENDOCINO, 1978 | *Oil on canvas* | *24 x 36 in.*

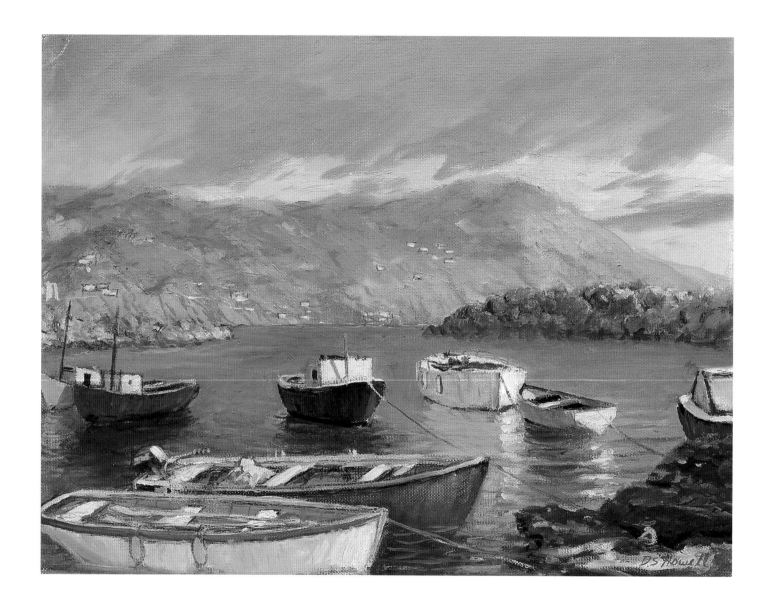

SAINT ANATOLE BREAKWATER, ISCHIA, 1993 | *Oil on canvas* | *12 x 20 in.*

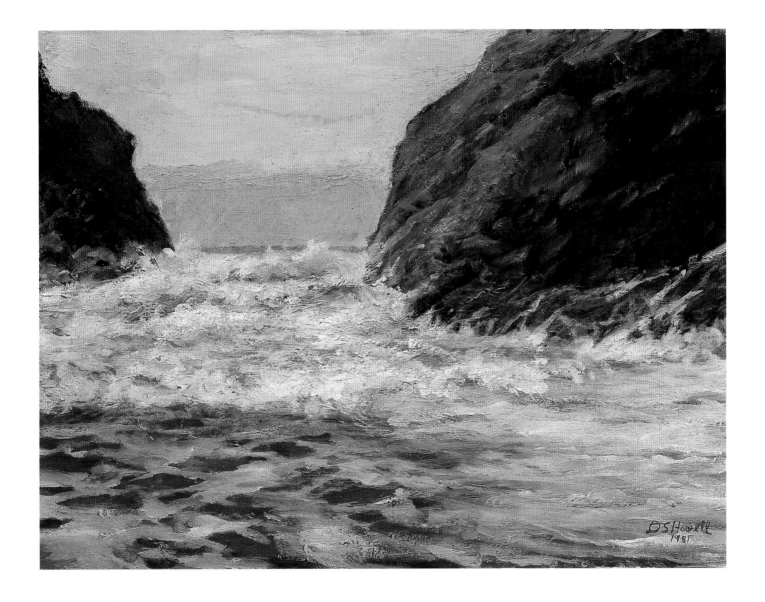

Narrow Entrance to Harbor Boscastle, Cornwall, 1978 | *Oil on canvas* | *12 x 16 in.* | *(Dangerous at times)*

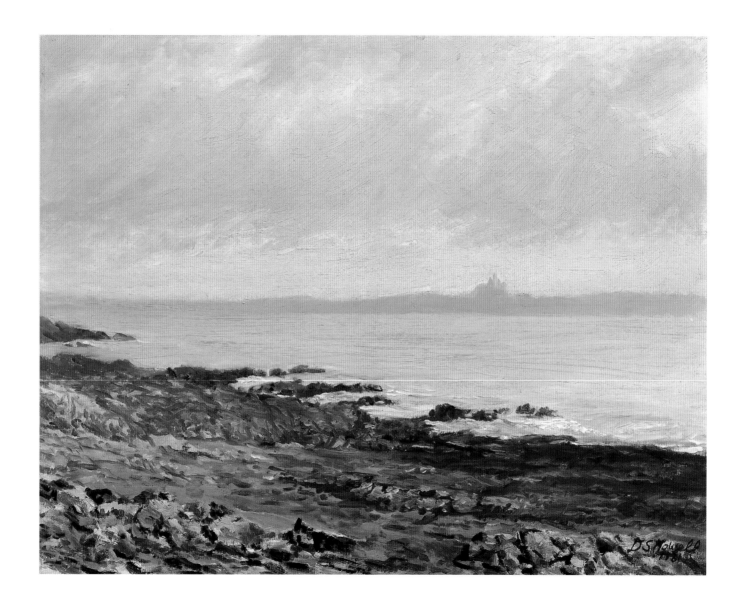

ROCKY SHORE NEAR PENZANCE, 1978 | *Oil on canvas* | *14 x 18 in.*

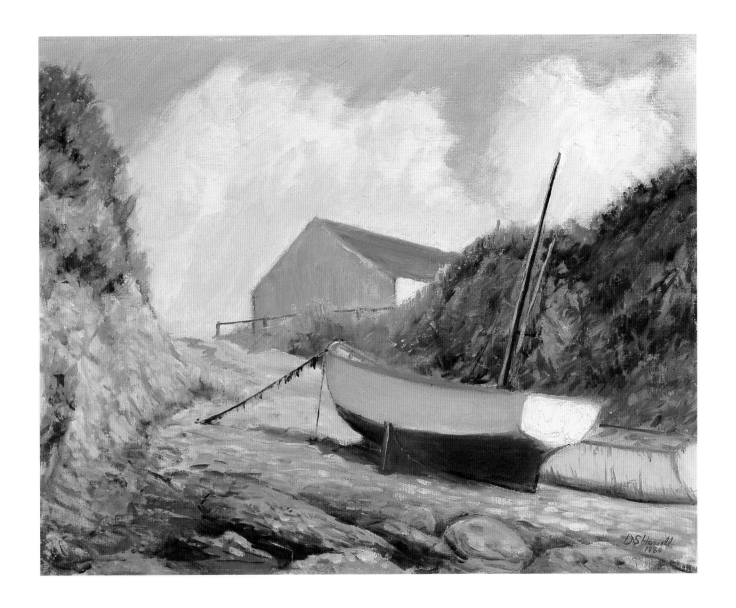

PEMBERTH COVE, CORNWALL, 1978 | *Oil on canvas* | *12 x 16 in.*

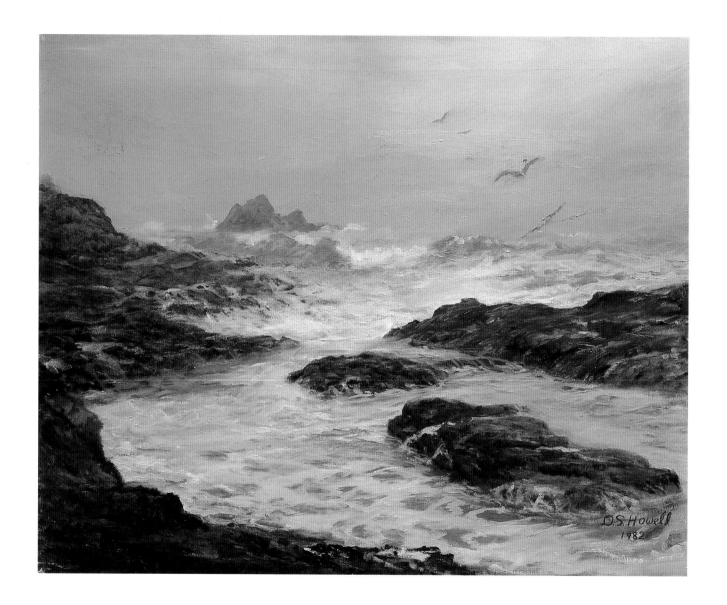

TIDAL POOL AT CAPE CORNWALL, 1980 | *Oil on canvas* | *14 x 28 in.*

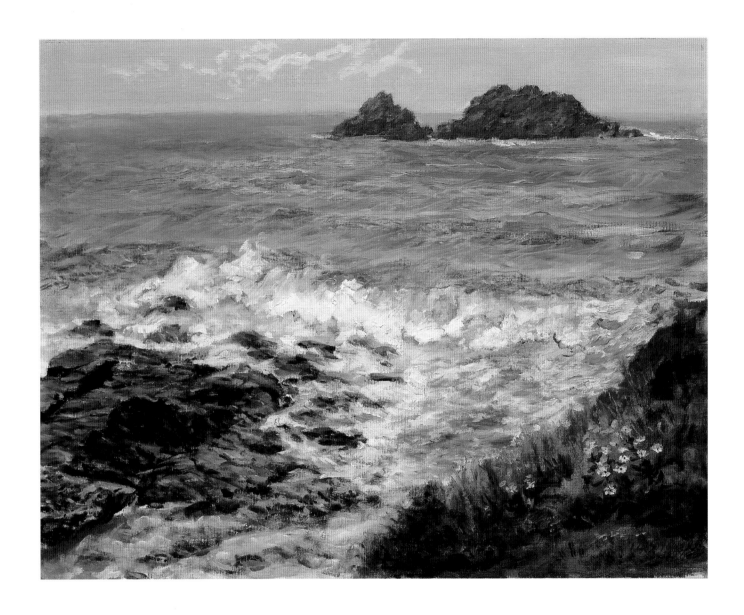

CAPE CORNWALL, 1980 | *Oil on canvas* | *14 x 18 in.*

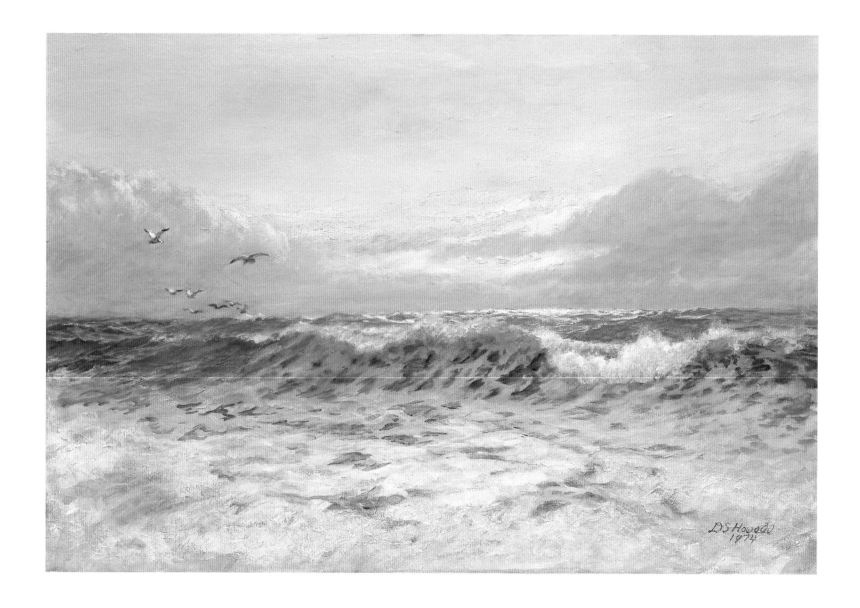

EARLY MORNING ON AN OUTER REEF, 1971 | *Oil on canvas* | *24 x 36 in.* | *(Hopetown, Bahama Islands)*

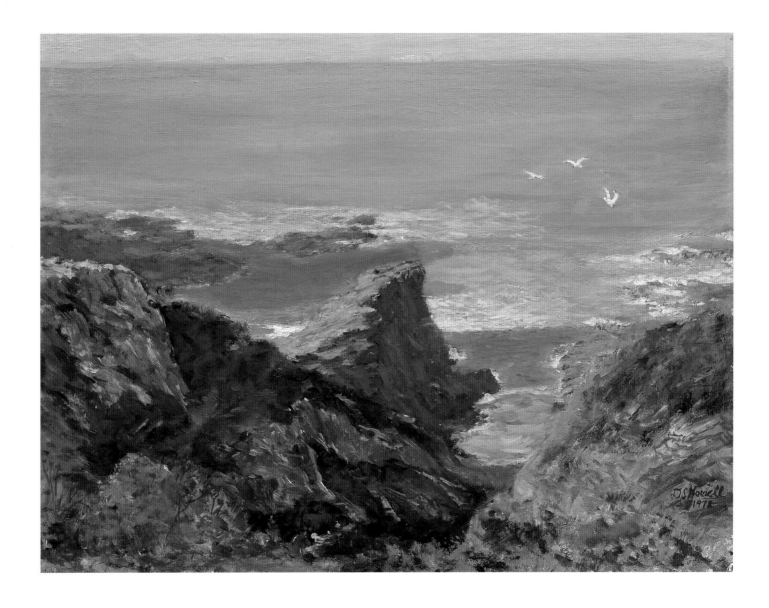

43

CLIFFS NEAR LANDS END, CORNWALL, 1978 | *Oil on canvas* | *12 x 16 in.*

44 SUMMER CLOUDS, BISCAYNE BAY, 1992 | *Oil on canvas* | *14 x 18 in.*

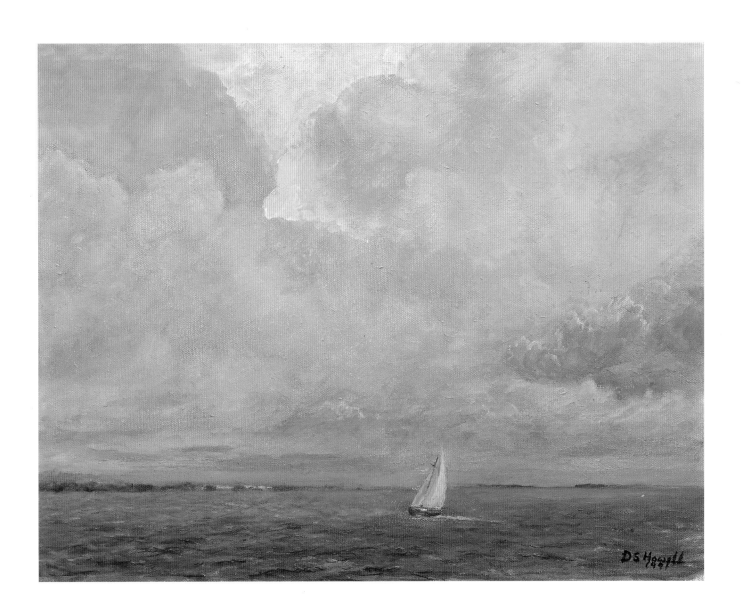

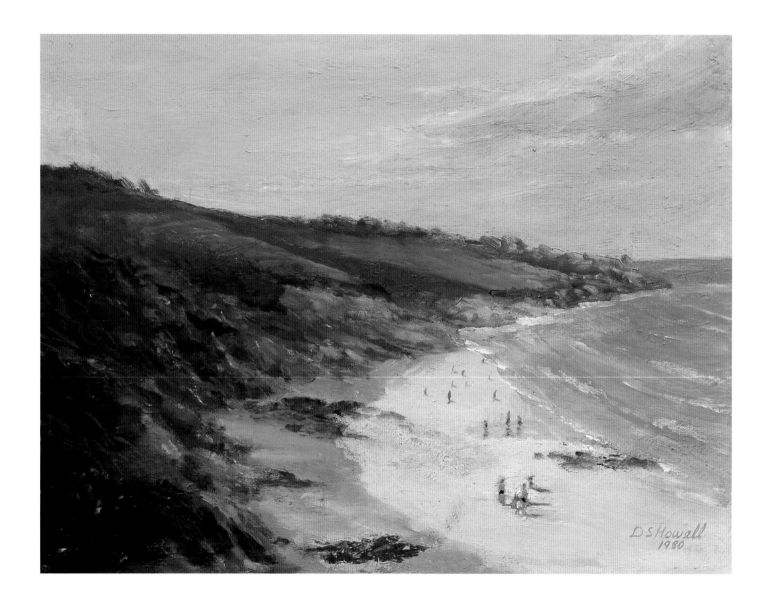

BEACH SCENE, ST. IVES, 1978 | *Oil on canvas* | *12 x 16 in.*

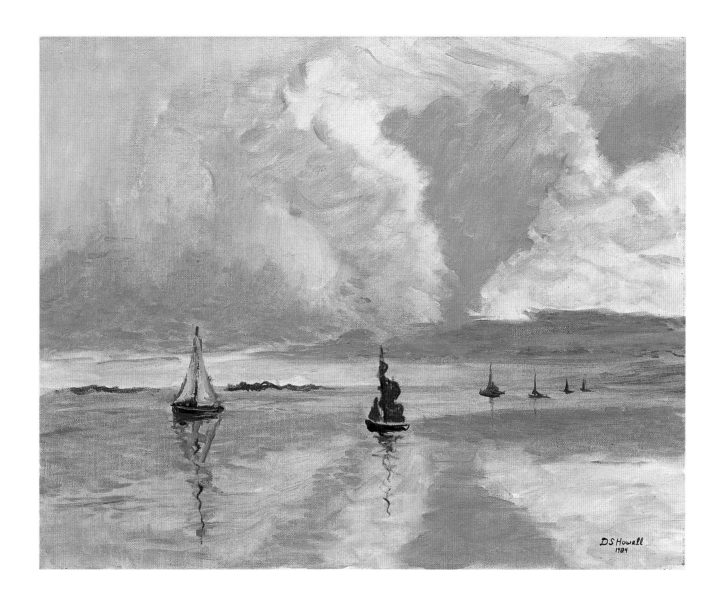

DOLDRUMS ON BISCAYNE BAY, 1984 | *Oil on canvas* | *12 x 16 in.*

48 Mangroves at Matheson Hammock, 1983 | *Oil on canvas* | *12 x 14 in.*

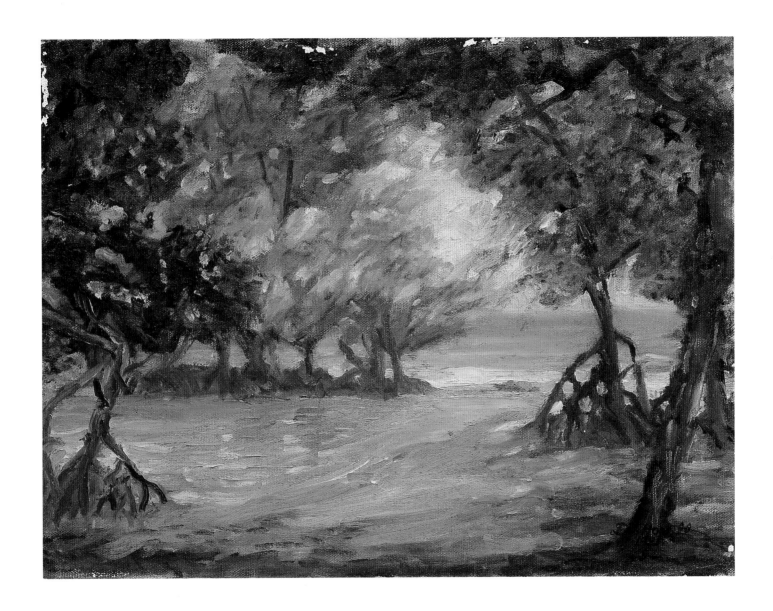

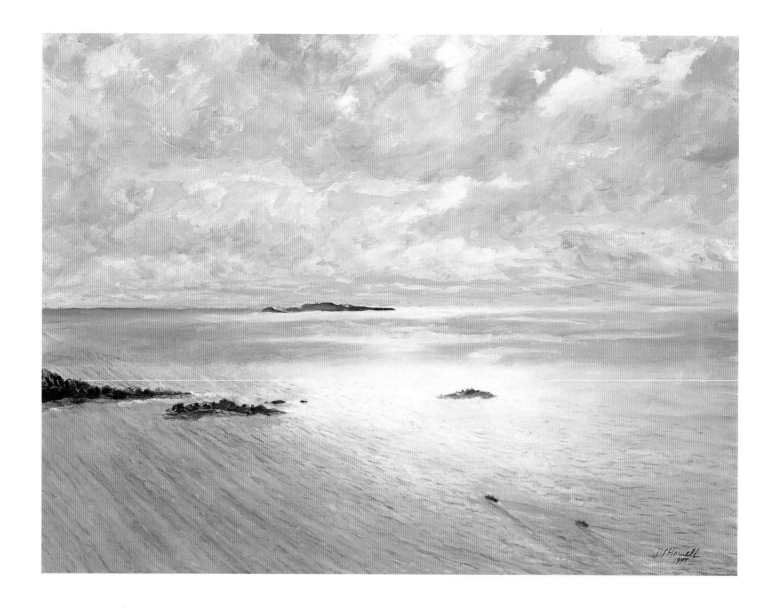

Aerial View of First Virgin Islands from Puerto Rican Coast, 1997 | *Oil on canvas* | *14 x 20 in.*

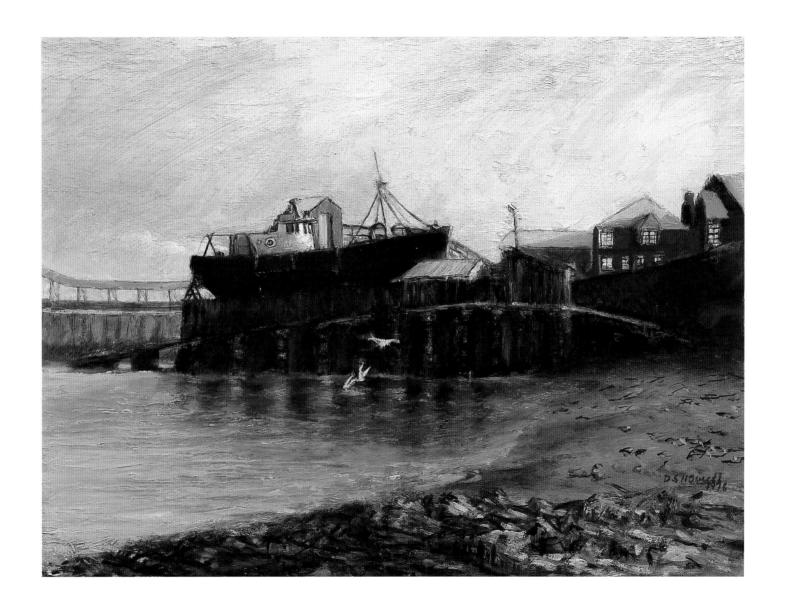

DRY DOCK AT NEWLYN, CORNWALL, 1981 | *Oil on canvas* | *12 x 16 in.*

INLET AT BLUE HILL, 2002 | *Oil on canvas* | *14 x 18 in.* | *(Penobscot Bay, Maine)*

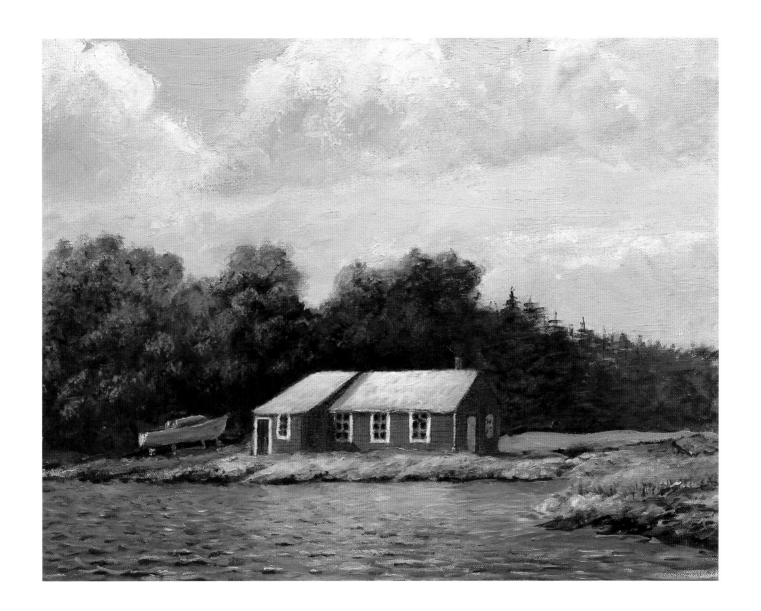

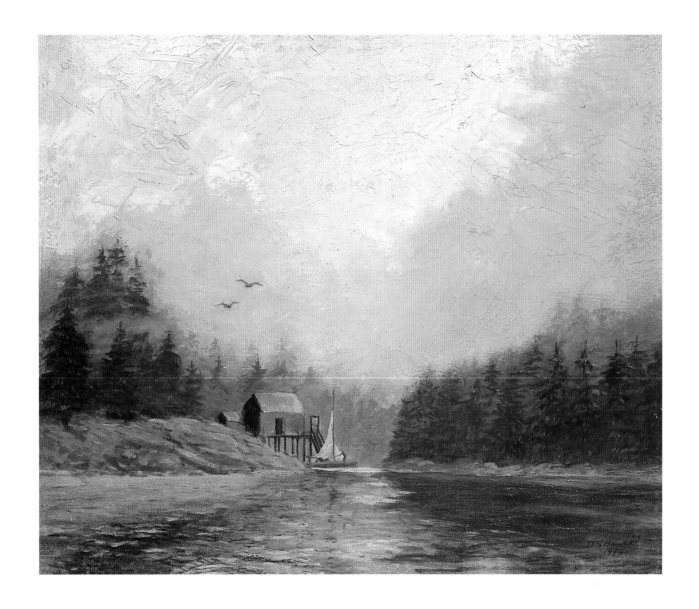

FOGGY DAY SOUTHPORT ISLAND, 1974 | *Oil on canvas* | *22 x 24 in.* | *(Maine)*

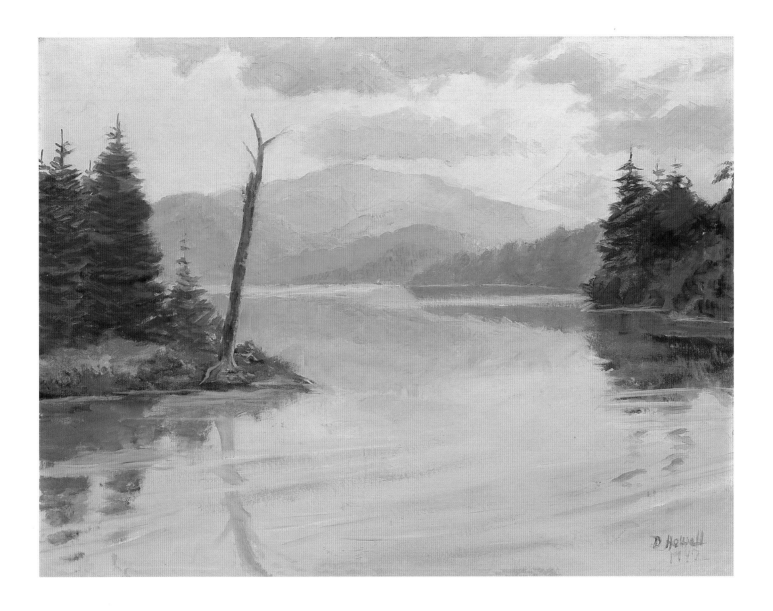

Lake Near Weld, 1947 | *Oil on masonite* | *18 x 24 in.* | *(Maine)*

Dense Forest near Moosehead Lake, 1960 | *Oil on masonite* | *12 x 24 in.* | *(Maine)*

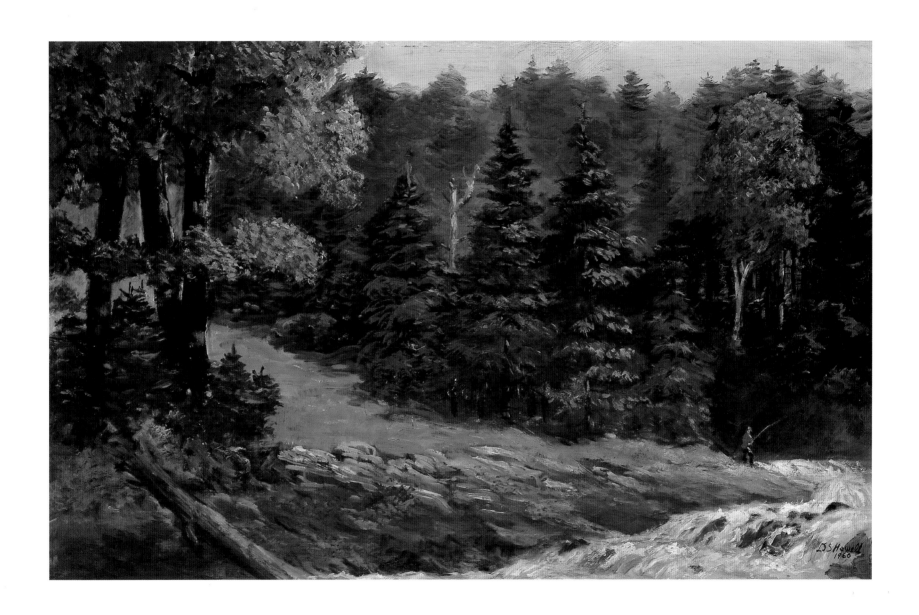

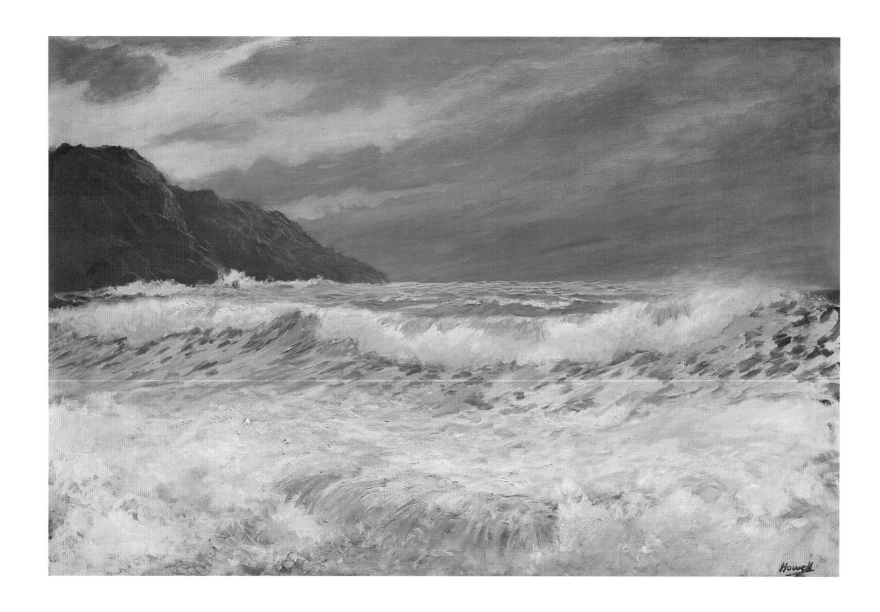

Scene South of Carmel, 1984 | Oil on canvas | 26 x 36 in.

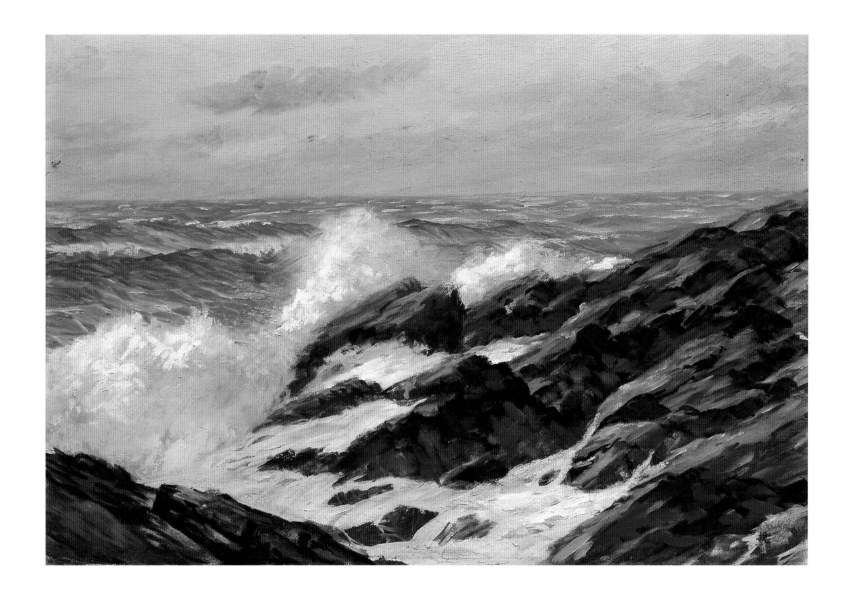

SURF AFTER SOUTHEAST STORM, PEMAQUID POINT, 1950 | *Oil on canvas* | *12 x 18 in.* | *(Maine)*

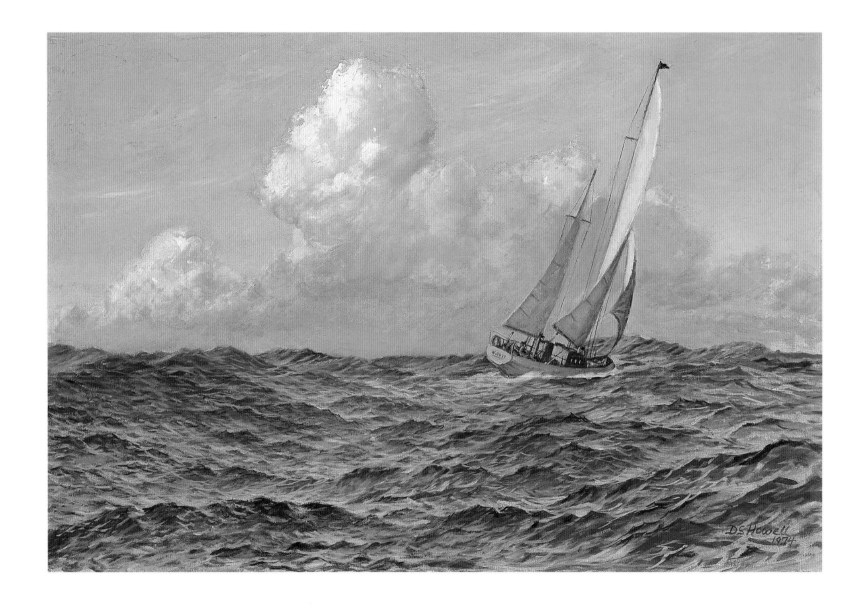

UNDER FULL SAIL, 1974 | *Oil on canvas* | *24 x 36 in.* | *(Wind shift after a storm)*

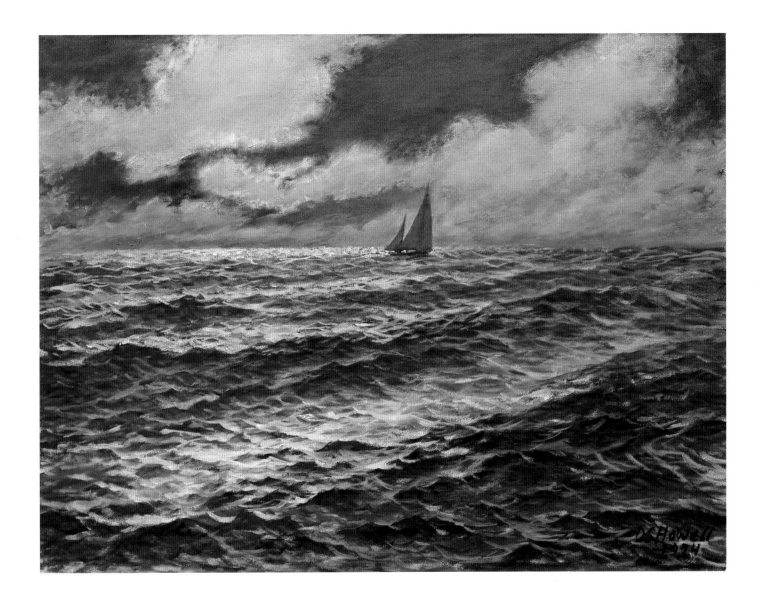

BRIGHT MOONLIGHT IN GULFSTREAM, 1974 | *Oil on canvas* | *18 x 24 in.*

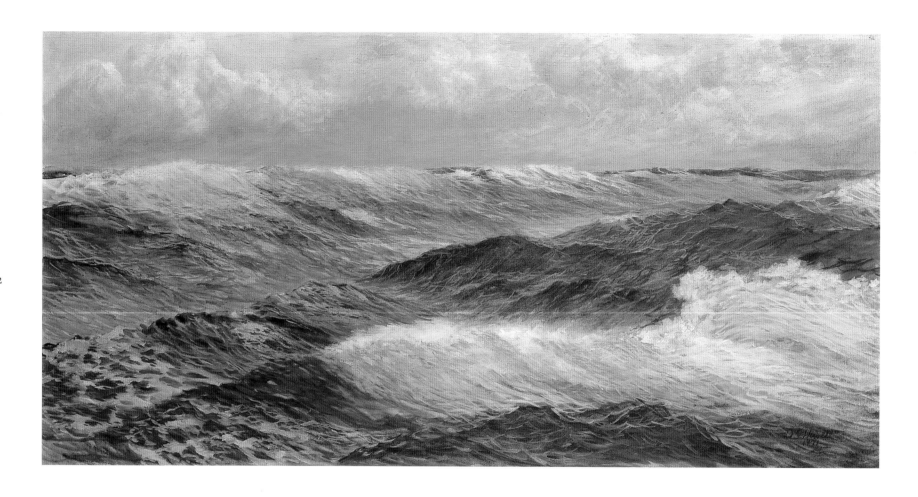

Edge of the Storm, Caribbean Sea, 1971 | *Oil on canvas* | *24 x 48 in.*

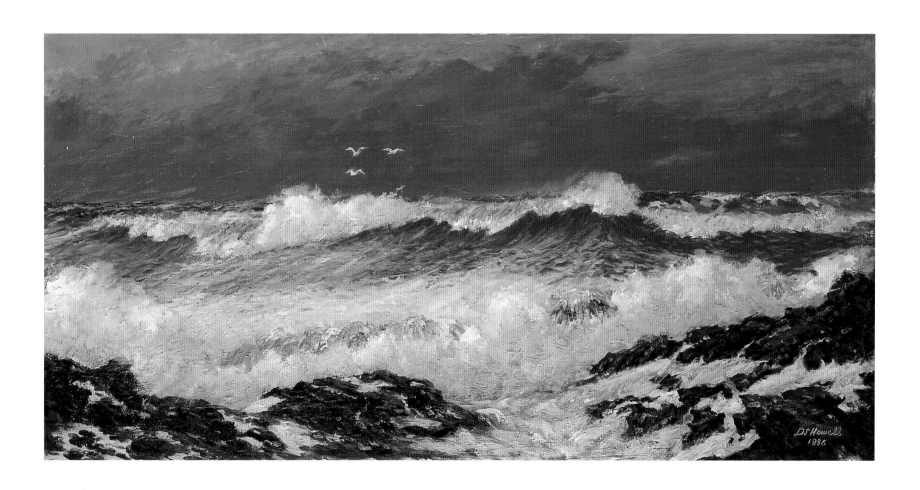

Storm Waves at Mendocino, 1986 | *Oil on canvas* | *24 x 48 in.*

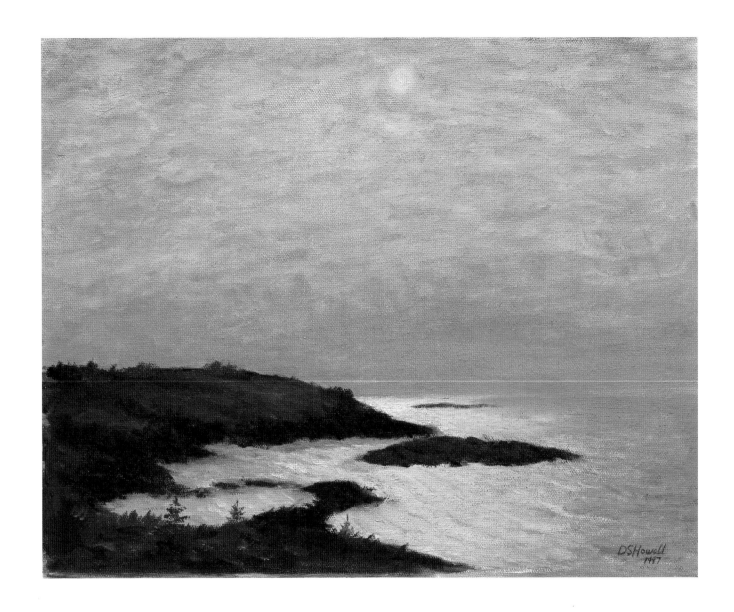

ISLE OF SHOALS, 1997 | *Oil on canvas* | *11 x 14 in.* | *(New Hampshire)*